Leabharlanna Atha Cliath
BALLYMUN LIBRARY
Inv/91 : BACKSTCK Price IR£
Title: REPRODUCTION OF COLOU
Class:

SANTRY BOOKSTORE DUBLIN CORPORATION PUBLIC LIBRARIES

31. MAY

08 1

STENY